C0-BOR-478

COMPLIMENTS OF
WILLIAM BLAIR & COMPANY

WOMEN WHO DARE

Women for Change

BY SARA DAY

Pomegranate

SAN FRANCISCO

LIBRARY OF CONGRESS
WASHINGTON, DC

Published by Pomegranate Communications, Inc.
Box 808022, Petaluma CA 94975
800 227 1428; www.pomegranate.com

Pomegranate Europe Ltd.
Unit 1, Heathcote Business Centre, Hurlbutt Road
Warwick, Warwickshire CV34 6TD, UK
[+44] 0 1926 430111; sales@pomeurope.co.uk

© 2007 Library of Congress. All rights reserved.
"Women Who Dare" is a registered trademark of Pomegranate Communications, Inc.
Registration No. 2160660

Amy Pastan, Series Editor

In association with the Library of Congress, Pomegranate publishes other books in the
Women Who Dare® series, as well as calendars, books of postcards, posters, and Knowledge Cards®
featuring daring women. Please contact the publisher for more information.

No part of this publication may be reproduced or transmitted in any form or by any means,
electronic or mechanical, including photocopying, recording, or by any information storage
or retrieval system, without permission in writing from the copyright holders.

Library of Congress Cataloging-in-Publication Data

Day, Sara, 1943–
 Women who dare : women for change / by Sara Day.
 p. cm.
 Includes bibliographical references.
 ISBN-13: 978-0-7649-3876-4
1. Women—United States—Biography. 2. Social reformers—United States—Biography. 3. Women
social reformers—United States—Biography. 4. United States—Social conditions. I. Library of
Congress. II. Title. III. Title: Women for change.
 CT3260.D394 2007
 920.72—dc22

 2006050349

Pomegranate Catalog No. A135
Designed by Harrah Lord, Yellow House Studio, Rockport, ME
Printed in Korea

16 15 14 13 12 11 10 09 08 07 10 9 8 7 6 5 4 3 2 1

FRONT COVER: *Women strike pickets from Ladies Tailors, New York,
February 1910.* LC-B2-957-1. GGBAIN 04507
BACK COVER: *Woman's Holy War: Grand Charge on the Enemy's Works,
Currier & Ives lithograph, 1874.* LC-USZ62-683. CPH 3A04601

PREFACE

FOR TWO HUNDRED YEARS, the Library of Congress, the oldest national cultural institution in the United States, has been gathering materials necessary to tell the stories of women in America. The last third of the twentieth century witnessed a great surge of popular and scholarly interest in women's studies and women's history that has led to an outpouring of works in many formats. Drawing on women's history resources in the collections of the Library of Congress, the Women Who Dare book series is designed to provide readers with an entertaining introduction to the life of a notable American woman or a significant topic in women's history.

From its beginnings in 1800 as a legislative library, the Library of Congress has grown into a national library that houses both a universal collection of knowledge and the mint record of American creativity. Congress' decision to purchase Thomas Jefferson's personal library to replace the books and maps burned during the British occupation in 1814 set the Congressional Library on the path of collecting with the breadth of Jefferson's interests. Not just American imprints were to be acquired, but foreign-language materials as well, and Jefferson's library already included works by American and European women.

The Library of Congress has some 121 million items, largely housed in closed stacks in three buildings on Capitol Hill that contain twenty public reading rooms. The incredible, wide-ranging collections include books, maps, prints, newspapers, broadsides, diaries, letters, posters, musical scores, photographs, audio and video recordings, and documents available only in digital formats. The Library serves first-time users and the most experienced researchers alike.

I hope that you, the reader, will seek and find in the pages of this book information that will further your understanding of women's history. In addition, I hope you will continue to explore the topic of this book in a library near you, in person at the Library of Congress, or by visiting the Library on the World Wide Web at http://www.loc.gov. Happy reading!

—JAMES H. BILLINGTON, The Librarian of Congress

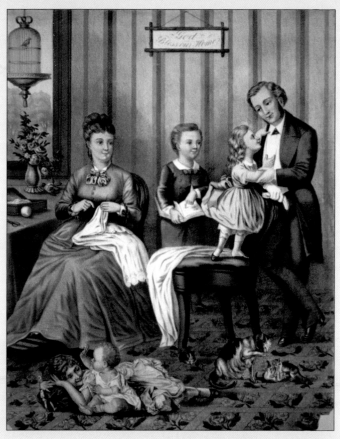

■ Home Sweet Home, *color lithograph by Muller & Company, c. 1880. Some nineteenth-century women reformers used the banner of "Home Protection" and the mantle of "Moral Motherhood" to win support for their programs from more conservative segments of society. Others fought the gender stereotyping that confined women to the domestic sphere.* LC-USZC4-1514. CPH 3B53018

WOMEN FOR CHANGE

Why not us? . . . If more-qualified people are up to the same thing, more power to them. But we don't know that, do we?
—Jane Jacobs, *Systems of Survival* (1992)

There have been legions of strong, visionary women who not only identified problems in American society but also dared to challenge the conventional barriers to effecting their reform. Many of the early female reformers were inspired by the social idealism of evangelical Protestant ministers, but their own paths to leadership were complicated by traditional constraints on women, including those from the church. The ways in which they succeeded in bringing about change attest to their imagination and drive.

Following the establishment of the federal government in 1789, the intellectual and religious establishment assigned American women a new role as the moral upholders of the Union. Women should confine themselves, they were told, to the domestic sphere and dedicate themselves to the responsibilities of "republican motherhood," as the nurturers, educators, and moral compasses of a nation of public-spirited male citizens. "Public" women were not "good" women, even though the country's highest aspirations were represented on coins and in public spaces as allegorical females—Love, Charity, Liberty, Justice, Peace, etc. This convention of separate spheres, ensuring women's invisibility in law and custom, was a prime barrier for those who wanted to empower

themselves and play a significant role in improving society. The best that most reform-minded women could hope for was to influence the men in their lives or help the poor through benevolent organizations.

But American society changed dramatically when the Industrial Revolution—which brought an increase in native and immigrant populations, urbanization, innovations in transportation, and the push to settle the vast western territories—transformed the nation's economy, social structure, and political institutions. Although the definition of republican womanhood did not fit poor women who had to work outside the home, often in factories and urban sweatshops, and did not relate to enslaved women of African descent, even following their emancipation in 1863, it remained an ideal to which all women were to aspire. As the traditional safety nets of church, family, and local community became inadequate for the increasingly overwhelming social problems of a far more complex society, women emerged as leaders of conscience by harnessing the spirit and forces of volunteerism.

REFORMING CONSERVATIVELY:
EDUCATION FIRST

THE FIRST IMPETUS FOR CHANGE came from pioneers in higher education for women. They knew they had to move carefully, working for reform while not appearing to challenge the sanctity of family or men's supremacy in public life. One such woman was Emma Hart Willard (1787–1870), who had grown up on a traditional New England farm, recognized women's intellectual deprivation following her marriage to a doctor, and determined to do something about it. She succeeded in reforming the curriculum for young ladies destined for marriage and motherhood by asserting that a classical and scientific education—rather than one focused on domestic skills—would produce better role models. Catherine Beecher (1800–1878), daughter of the Calvinist theologian Lyman Beecher and sister of abolitionist writer Harriet Beecher Stowe, was deeply influenced by evangelical Protestantism, with its initiative for reform. Besides founding several schools of higher education for women, including the academically rigorous Hartford Female Seminary in 1823, she was the driving force behind the American Woman's Educational Association and the author of nearly thirty publications, several urging the reform of women's domestic lives and extolling the benefits of women receiving an education comparable with that of men. Although she apparently hewed to the ideal of separate spheres for men and women, she cleverly persuaded the public that women could also be educated "to teach the children of others," planting the seeds for women's entry into teaching, "a profession offering influence, respectability and independence."

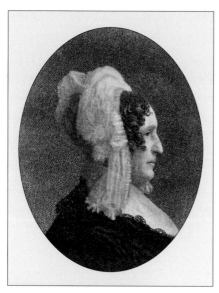

■ *Emma Hart Willard opened her Troy Female Seminary in 1821 when the Troy, New York, Common Council offered to raise the money to establish a girls' school through taxation. Alongside instruction in the "social graces," Willard's curriculum emphasized such "unwomanly" subjects as zoology, anatomy, geometry, and trigonometry. By 1831, the seminary had enrolled more than one hundred boarding students and more than two hundred day students. The school was profitable, and Willard also made money with her textbooks based on courses of study in the school, particularly in geography and history.*

LIBRARY OF CONGRESS RARE BOOK AND
SPECIAL COLLECTIONS DIVISION, RBPE 13001400

A
SERIES OF MAPS
TO
WILLARD'S
History of the United States,
OR
REPUBLIC OF AMERICA.

DESIGNED FOR SCHOOLS AND PRIVATE LIBRARIES.

NEW-YORK:
WHITE, GALLAHER & WHITE,

1828

■ *Title page of* A Series of Maps to Willard's "History of the United States," *1828.*

LIBRARY OF CONGRESS GEOGRAPHY AND MAP DIVISION,
G3701SM GCT00033

Title page of Catherine Beecher's Treatise on Domestic Economy, *1845. In the preface to the treatise, written "as a text-book for female schools," Beecher expressed dismay over the evidence she had seen in the course of her extensive travels that women were failing in their roles as wives and mothers because they "are not trained for their profession." She was particularly concerned about the poor health, often to the point of invalidism, of many women in the wealthier classes, which she attributed to a lack of exercise and inadequate knowledge of the importance of good nutrition and sanitation: "Educate a woman, and the interests of a whole family are secured," she insisted.*
LIBRARY OF CONGRESS GENERAL COLLECTIONS

Despite the reforms that they advocated for improving women's education, competence, and prospects, Willard ignored and Beecher opposed the political and legal demands of the early suffrage movement. Beecher felt it risked undermining the gender hierarchy by "uniting all the antagonisms that are warring on the family state," as she declared in an open ideological conflict with abolitionist Angelina Grimké, who repudiated artificial boundaries between men's and women's social responsibilities.

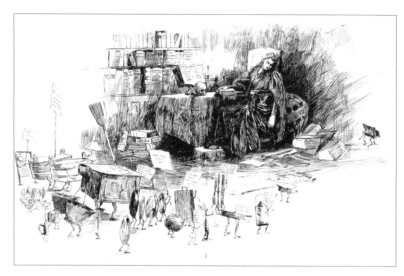

■ For the Benefit of the Girl Who Is About to Graduate, *lithograph from* Life, *May 22, 1890. In a traditionalist view of female education, an exhausted young scholar, or bluestocking, sleeps at her desk as a nightmarish army of domestic paraphernalia threatens to overwhelm her. Addressing those who questioned the value of higher education for women, most of the pioneer women's colleges advertised similar philosophies and goals: to produce enlightened mothers, wives, and social exemplars. In 1835 Oberlin College became the first institution of higher education to open its doors to people of color; it opened them to women two years later. The first college intended exclusively for women was Mount Holyoke Female Seminary, founded in 1837 by Mary Lyon. Other women's colleges began to emerge after the Civil War.* LC-USZ62-58805. CPH3606606

MISSIONARY ZEAL

DOROTHEA DIX (1802–1887), a pioneering crusader for the institutional treatment and care of the mentally ill, interpreted her religious views as a mandate for social reform. Rigidly self-disciplined and self-taught, she drove herself as a teacher and writer in Boston, where her pupils included the children of the great Unitarian minister and reformer William Ellery Channing, an important influence on her growing desire to give her life to social service.

In 1840, the insane numbered 17,456 out of a total American population of just over seventeen million, but the country had only fourteen hospitals for the mentally ill with just 2,500 beds among them. The mentally ill were frequently housed with criminals and vagrants and treated inhumanely. Dix first became aware of the problem after teaching a Sunday school class in the women's department of the East Cambridge (Massachusetts) House of Correction. Horrified by the jailer's lack of concern about some emotionally disturbed prisoners confined in a "dreary, unsanitary, and unheated room," she initiated an investigation that resulted in a court ordering the quarters of the mentally ill to be heated. She shared the popular conviction that an environment of kindness and discipline would cure many of the afflicted, while she was blind to the potential devastation of incarcerating the nonviolent insane.

In her famous "Memorial to the Legislature of Massachusetts," Dix documented horrendous conditions and insisted that the commonwealth had a legal, moral, and humanitarian obligation toward the mentally ill. In return, she was accused of "sensational and slanderous lies" and of being a sentimental idealist and interfering woman. In the face of such reactions and conforming to the period's canon of female behavior, she never appeared before

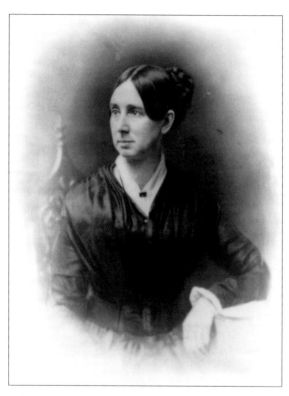

■ *When Dorothea Dix arrived in New Jersey in 1844, she saw "scenes of almost incredible sufferings," large numbers of the insane in jails, poorhouses, and wandering unchecked through the countryside. She contended that "on the ground of discreet economy alone, it is wise to establish a State Hospital in New Jersey." Her tireless efforts resulted in a bill authorizing the establishment of a state hospital, which opened near Trenton in 1848.*
LC-USZ62-9797. CPH 3A12244

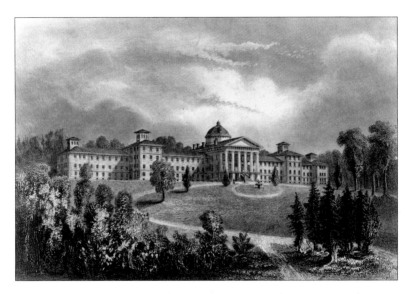

■ New Jersey State Lunatic Asylum, Trenton, *engraving, between 1848 and 1880.*
LC-USZ62-127644. CPH 3C27644

legislatures herself but instead enlisted influential men to fight publicly while she provided the grist and lobbied behind the scenes.

In the decade before the Civil War, Dix traveled over thirty thousand miles, visiting hundreds of prisons, poorhouses, jails, and hospitals, compiling data and making careful notes of conditions for her emotionally charged memorials. By 1850, at least partly through her efforts, the number of hospitals for the insane in the United States had risen to 123.

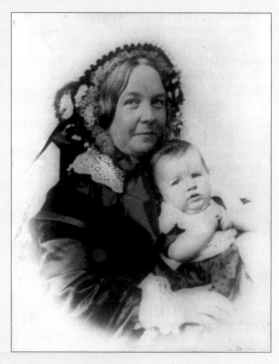

■ *Elizabeth Cady Stanton and her daughter, Harriot, 1856.*
LC-USZ62-48965. CPH 3A49096

DEMANDING EQUAL RIGHTS

WHILE NOT ALL REFORMERS were radicals, what were the so-called radicals calling for? Elizabeth Cady Stanton (1815–1902) was the chief intellectual of the women's rights movement immediately before the Civil War. She rebelled against the view that women were legally and intellectually inferior to men and urged them to question any pronouncement of church or state that confined their sphere of influence.

Despite the responsibilities of marriage and a large family, Stanton organized the Seneca Falls women's rights convention in 1848 and wrote its famous feminist document, "A Declaration of Sentiments." Following the Civil War, she continued to air her radical ideas in the journal *Revolution*, advocating women's suffrage, jury service, wider economic opportunities for women, and more liberal divorce laws (a temperance activist, she believed that drunkenness should be sufficient cause for divorce). Her columns also condemned prostitution and the Fifteenth Amendment for, as one scholar put it, "establishing the principle of man government and enshrining women's exclusion from the franchise in the Constitution."

Stanton's most courageous and controversial battle began after the death of her husband in 1887. The greatest obstacles to women's progress, she claimed, were the church and its interpretation of the Bible. She and a committee of women embarked on a thorough study and reinterpretation of the Bible's derogatory references to women: The result was *The Woman's Bible*, published in 1895 to a storm of criticism, but quickly a best seller. As she wrote in her introduction, the Bible teaches that "woman was made of man, after man, and for man, an inferior being, subject to man . . . [and] that woman brought sin and death into the world, that she precipitated the fall of the race. . . ." ■

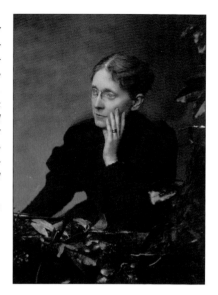

■ *The banner of "Home Protection" resonated with women who had little or no support if the economic security of their families was threatened or ruined by their husbands' alcoholism. An attractive, humorous, eloquent, and charismatic woman, Frances Willard inspired temperance workers to "Do Everything" in their crusade for social justice: "Every question of practical philanthropy or reform has its temperance aspect, and with that we are to deal," she said.*

LC-USZ61-790. PPMSC 00035

Frances Willard (1839–1898) succeeded in leading conservative church-women into respectable political action by invoking women's traditional role as defenders of their homes and families. She grew up as a tomboy on her family's frontier farm in Wisconsin Territory. "I 'ran wild' until my sixteenth birthday," she wrote later. Despite her father's opposition, she was educated in the Methodist-affiliated North-Western Female College in Evanston, Illinois.

As president of the Evanston College for Ladies, and then dean of women and a professor when it was absorbed by Northwestern University, she resigned following challenges to her authority by Northwestern's new president, her former fiancé, Methodist pastor Charles Fowler. In 1874, Willard

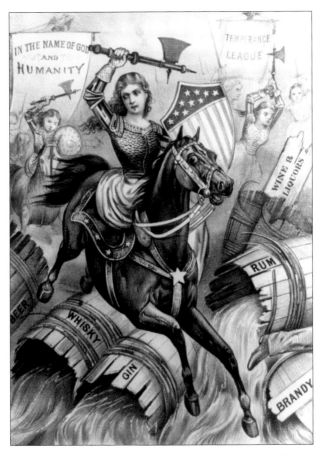

■ Woman's Holy War: Grand Charge on the Enemy's Works,
Currier & Ives lithograph, 1874. LC-USZ62-683. CPH 3A04601

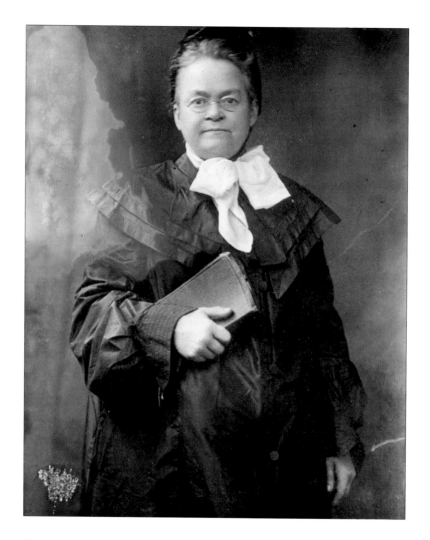

turned her leadership talents to the fledgling Chicago temperance movement. Before the Civil War, leadership of the movement had been barred to women, but this changed spontaneously in response to the growing problem of alcoholism, when, in December 1873, praying bands of women launched an anti-saloon crusade in several Ohio and western New York towns. This effort eventually involved fifty-six thousand women and reportedly caused the closure of about three thousand liquor shops in the first six months.

Willard was chosen president of the Illinois Woman's Christian Temperance Union (WCTU) in 1878 and, with her friend and secretary Anna Gordon, organized a massive "Home Protection" petition to the state legislature. She became president of the national WCTU the following year and remained in that position the rest of her life. Willard immediately pushed the WCTU to endorse "the ballot for woman as a weapon for the protection of her home." From then on, the union was a powerful women's movement, laying the foundations for some of the most important reform agendas of the twentieth century.

■ *Carry Nation (1846–1911) drew attention to the temperance movement by adopting a confrontational approach, her radical behavior stemming from her first brief marriage to a hopeless alcoholic. A founder of a Kansas WCTU chapter and an eventual embarrassment to the national organization, she gravitated from participation in peaceful "prayer meetings" blocking saloon entrances to more violent tactics, including wielding an axe. Nationally famous after demolishing the Kansas Senate saloon in 1901, she lectured from coast to coast, selling her autobiography and thousands of miniature hatchets engraved "Carry Nation Joint Smasher."*

LC-B2-1131-3. GGBAIN-05640

■ *Although Jane Addams was well educated and ambitious, her father and stepmother insisted that an unmarried daughter of independent means should devote herself to family, travel, and finding a husband. Frustrated by ill health in her desire to become a doctor and searching desperately for more meaning in her life, she made up her mind to rent a house in a poor district of a city and persuade other educated young women to join her for a life of service. Addams and Ellen Gates Starr filled the once-elegant Hull House with an eclectic mix of furniture, paintings, and heirlooms, envisioning it as their permanent residence and a model for their new neighbors' aspirations.*

PHOTOGRAPH BY WALLACE KIRKLAND. JANE ADDAMS MEMORIAL COLLECTIONS (JAMC NEG. 21), SPECIAL COLLECTIONS DEPARTMENT, UNIVERSITY LIBRARY, UNIVERSITY OF ILLINOIS AT CHICAGO

THE SETTLEMENT MOVEMENT:
SEEDBED FOR PROGRESSIVE REFORMS

FRANCES WILLARD was part of a group of single, educated, middle-class women who dominated the reform movement's leadership from the 1870s through World War I. Particularly attractive to the first generation of college-educated women were the settlement houses established in American cities struggling with the massive influx of immigrants, because they offered an alternative to marriage, a structure that allowed single women to live independent working lives. One study found that while 80 percent of all women married, only 28 percent of college-educated women did so. The idea of encouraging university students to help the urban poor by living among them originated in England. By the late nineteenth century, settlement houses were being established in America; the most famous were perhaps Hull House in Chicago and the Henry Street Settlement in New York.

Jane Addams (1860–1935) opened Hull House with her friend Ellen Gates Starr in September 1889. In 1893, Lillian Wald (1867–1940), unaware of the pioneering Hull House, gave up medical school and moved to the Lower East Side of Manhattan with a friend, Mary Brewster, to establish a "Nurses' Settlement." In 1895, the settlement moved into its permanent home on Henry Street and adopted that name. These two organizations would have many interconnections during their peak years from 1893 to 1922. In fact, like Frances Willard's WCTU, they campaigned for the entire spectrum of the Progressive reform agenda: excellent public education, protective labor laws, women's suffrage, municipal reform, recreational facilities, affordable housing, and city planning.

About fifty thousand people of nineteen different nationalities,

overwhelmingly Catholic and Orthodox Jewish, lived in appallingly sordid and crowded tenements in the Nineteenth Ward surrounding Hull House, while workers, including children, labored in unregulated factories and sweatshops. The ward had 255 saloons, including eight in the immediate neighborhood.

Always a pragmatist, Addams employed the terms of Protestant piety to raise funds from churchwomen, although her approach was secular; she used the vocabulary of Victorian womanhood and social convention while addressing realities in a world without privileges. "Miss Addams," recalled a volunteer, "had a rare way of . . . letting people work out their own plans." She believed that the goal of self-reformation was no less important than social reform, and that when residents really listened to their neighbors, they learned what reforms were needed. Addams became the principal theorizer and leader of the American settlement movement, lecturing widely and publishing ten books and more than a hundred magazine and journal articles over the next forty years.

THE HULL HOUSE SORORITY. An extraordinary network of women began their careers in reform at Hull House, acting first as ombudsmen to local authorities on behalf of their less articulate neighbors, and then moving out to establish new professions and institutions to help the working poor. Hull House filed 1,037 complaints with the Chicago Health Department during the summer of 1892 and became the district headquarters for the Central Relief Association, distributing coal, clothing, and fuel to desperate families during the depression of 1893. Julia Lathrop and Florence Kelley were part of Hull House's inner circle. Other important residents included Grace and Edith Abbott, Sophonisba Breckenridge, and Dr. Alice Hamilton.

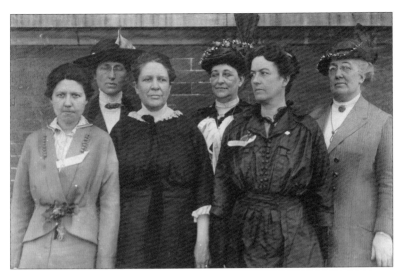

■ *Factory inspectors past and present, March 1914. An outstanding cross-pollinator of reformist initiatives, Florence Kelley (1859–1932), shown third from left, spearheaded Hull House's voluminous research on sweatshops and living conditions in the slums. Appointed by the United States commissioner of commerce and labor to conduct research on Chicago's sweatshops, she also wrote a factory inspection bill and forcefully guided it through the Illinois legislature, served as the state's chief factory inspector, and earned a law degree at Northwestern University. Jane Addams' favorite nephew described the ferociously intelligent but carelessly dressed Kelley as "the toughest customer in the reform riot, the finest rough-and-tumble fighter for the good life of others that Hull-House ever knew. Any weapon was a good weapon in her hand—evidence, argument, irony or invective." In 1899, she was invited by Lillian Wald to chair the National Consumers' League and moved with her three children to New York to live in Wald's Henry Street Settlement.* PHOTOGRAPH BY LEWIS W. HINE. NCLC-04941

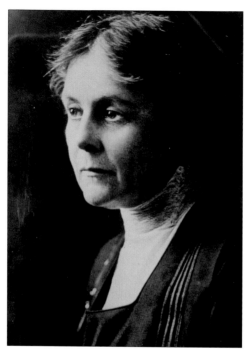

■ *Alice Hamilton (1869–1970), who held a medical degree from the University of Michigan, was the last to join the Hull House family. Hamilton's first project at Hull House was a "well-baby clinic" in the basement, fitted up with a dozen little bathtubs. There she cared for infants from the surrounding slums and taught their mothers about nutrition and hygiene. Hamilton also investigated the physiological impact of various environmental factors in the Hull House neighborhood, traveled widely in her investigations of workplace safety, and wrote a textbook on dangerous professions. She left Hull House in 1919 to take the position of professor of industrial medicine at Harvard Medical School, becoming the first woman faculty member there.* LC-B2-5068-14. GGBAIN-29701

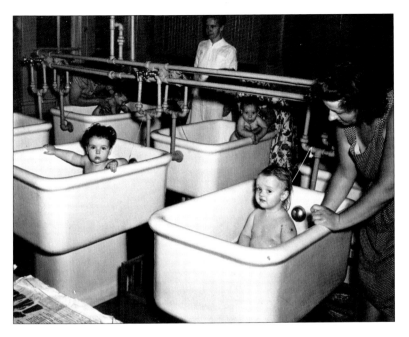

■ *Bath time in Dr. Alice Hamilton's Hull House well-baby clinic.*

JANE ADDAMS MEMORIAL COLLECTIONS (JAMC NEG. 607), SPECIAL COLLECTIONS DEPARTMENT,
UNIVERSITY LIBRARY, UNIVERSITY OF ILLINOIS AT CHICAGO

ECONOMIC INDEPENDENCE?

CHARLOTTE PERKINS GILMAN (1860–1935) was the leading intellectual of the women's movement following the death of Elizabeth Cady Stanton. She challenged traditional views on the primacy of marriage and motherhood and the resulting dependency of women on men for their livelihood.

While writing and lecturing to support herself after her divorce, Gilman honed her ideas on women, labor, and social organization. Following a stay at Hull House, she published *Women and Economics* (1898), her powerful argument for female independence. The obvious remedy, she claimed, was to educate women so that their livelihood no longer depended on attracting and holding onto males. She argued for centralized nurseries and cooperative kitchens run by trained personnel and continued her attacks on sentimental and traditional views in books and magazine articles. In January 1915, she cofounded, along with Jane Addams and others, the Woman's Peace Party.

Gilman's decision to leave her husband, move to California, and then later send their young daughter back to live with him and his new wife (her best friend) incurred severe criticism from society and the press. She succeeded in maintaining a good relationship with all of them, and eventually remarried, but this cartoon represents the prevailing attitude that ambition in women would inevitably lead away from the joys of domesticity to loneliness and unhappiness, an argument that continues to be made. ∎

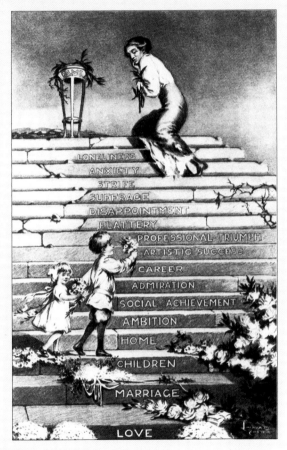

■ Looking Backward, *cartoon by Laura E. Foster from* Life, *August 22, 1912.* PPMSCA 02940

LONELINESS
ANXIETY
STRIFE
SUFFRAGE
DISAPPOINTMENT
FLATTERY
PROFESSIONAL TRIUMPH
ARTISTIC SUCCESS
CAREER
ADMIRATION
SOCIAL ACHIEVEMENT
AMBITION
HOME
CHILDREN
MARRIAGE
LOVE

■ *Charlotte Perkins Gilman, 1900.* LC-USZ62-106490. CPH 3C06490

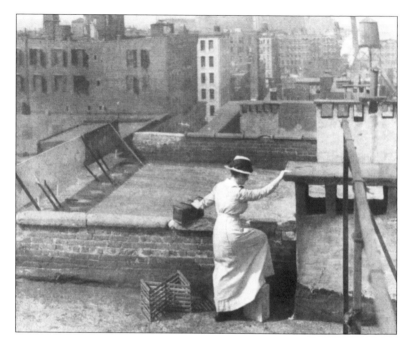

■ *A visiting nurse takes shortcut over the roofs of the tenements, from* The House on Henry Street *by Lillian Wald, 1915. A warm and ebullient woman, Lillian Wald, like Jane Addams, was born into a prosperous family. After a few years of enjoying life, the twenty-one-year-old wrote in 1889, "I feel the need of definite serious work," and chose nursing. By 1913, ninety-two nurses were making two hundred thousand visits annually from Wald's Henry Street Visiting Nurses Service headquarters on the Lower East Side and branches in upper Manhattan and the Bronx. A new profession, public health nursing, was born out of the Henry Street experiment. In the meantime, the settlement, entirely dependent on voluntary contributions, had grown into a neighborhood center for educational and social welfare.* LIBRARY OF CONGRESS GENERAL COLLECTIONS

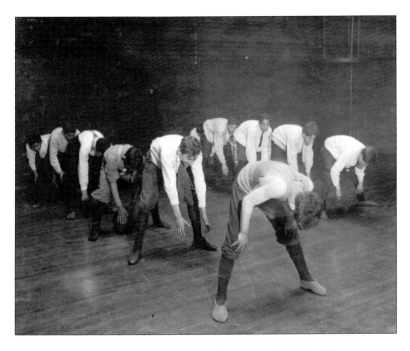

■ *A game in the gymnasium, Henry Street Settlement, New York City, May 1910.*
PHOTOGRAPH BY LEWIS W. HINE. NCLC-04578

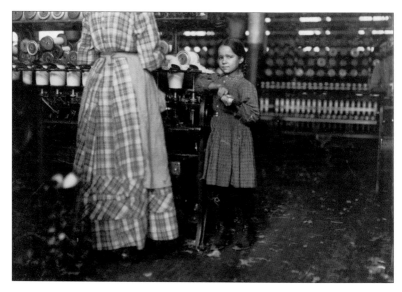

■ *ABOVE:* A seven-year-old mill worker, Tennessee, 1910. *OPPOSITE:* Children making wreaths, New York, 1912. *In 1904, Lillian Wald and Florence Kelley founded the National Child Labor Committee. Wald worked for many years for legislation outlawing child labor. Sociologist Lewis Hine joined the committee as an investigative photographer and, from 1908 to 1912, traveled across America photographing children as young as three who worked long hours, often in dangerous conditions. Wald's suggestion that President Theodore Roosevelt set up a federal children's bureau, made in 1905, bore fruit seven years later.*

PHOTOGRAPHS BY LEWIS W. HINE FOR THE NATIONAL CHILD LABOR COMMITTEE.
NCLC-01893 (ABOVE) AND NCLC-04146

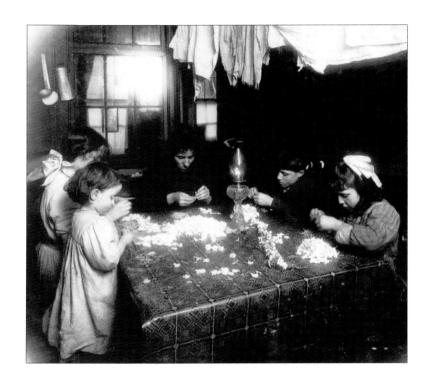

A TRULY DARING REFORMER

IDA B. WELLS (1862–1931) was born to slaves in rural Mississippi and freed by the Emancipation Proclamation the following year. Both of her parents died when Wells was sixteen, and she went to work as a teacher to support her siblings. She moved to Memphis in 1884 and continued teaching while attending summer classes at Fisk University. Turning to journalism, she became co-owner of the Memphis *Free Speech and Headlight* newspaper and a community activist. In March 1892, three men, friends whom she knew to be innocent of the usual pretext of rape, were jailed and then shot merely for competing successfully with local white storekeepers. As Wells was to write in her memoirs, "This is what opened my eyes to what lynching really was. An excuse to get rid of Negroes who were acquiring wealth and property and thus keep the race terrorized and 'keep the niggers down.'"

In a pseudonymous editorial dated May 21, 1892, she wrote: "Nobody in this section of the country believes the old thread bare lie that Negro men rape white women. If Southern white men are not careful, they will over-reach themselves and public sentiment will have a reaction; a conclusion will then be reached which will be very damaging to the moral reputation of their women." The editorial brought an immediate and vicious response: for daring to hint that sex between white women and black men was consensual, and for drawing attention to the long history of white men raping black women, her newspaper's offices were mobbed and destroyed while she was away in Philadelphia.

Calling herself "exiled," Wells launched a one-woman crusade against lynching, describing the Memphis events and similar lynchings throughout the

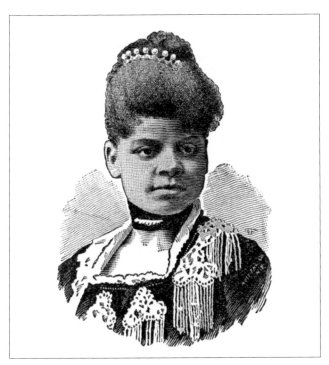

■ *Portrait of Ida B. Wells, from* The Afro-American Press and Its Editors *by I. Garland Penn, 1891. Wells fought lynching by trying to change public opinion, speaking all over the United States, except the South, and Great Britain, which she toured twice. She moved to Chicago and threw herself into raising money to print twenty thousand copies of a booklet she coauthored,* The Reason Why the Colored American Is Not in the World's Columbian Exposition. *Realizing that African Americans were being systematically excluded from participating, she had collaborated with abolitionist leader Frederick Douglass; lawyer, newspaper owner, civic leader, and her future husband, Ferdinand L. Barnett; and newspaper editor I. Garland Penn in documenting the achievements and repressions of blacks. The booklet included her article "Lynch Law."*

LC-USZ62-107756

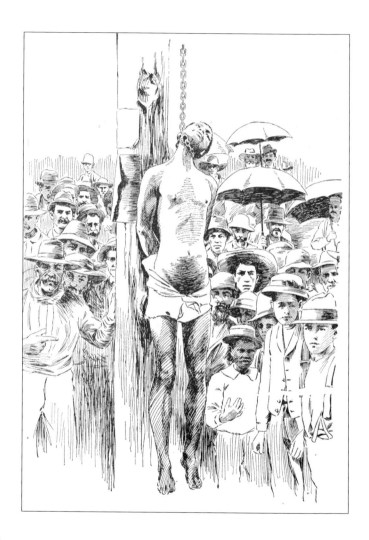

South in an article for the *New York Age*, which was reprinted and widely distributed as the pamphlet *Southern Horrors* with money raised by hundreds of African American clubwomen. Wells was writing in the context of Jim Crow laws, that is, the legalized repression that white Southerners imposed on blacks through disenfranchisement, segregation, and the threat of violence.

Marginalized nationally after she was excluded from the leadership of the National Association for the Advancement of Colored People (NAACP), despite her participation in its founding meetings, and by now the mother of four, Ida B. Wells-Barnett turned her attention to the welfare of Chicago's burgeoning black population. She founded several sociopolitical clubs, including the Negro Fellowship League, a settlement for African American men and boys. Although organizations such as the NAACP learned from both white and black resistance to Wells-Barnett's approach to seek remedies through education and legislation rather than direct confrontation, she succeeded in making lynching a legitimate focus of American reform efforts.

■ Lynching of C. J. Miller, at Bardwell, Kentucky, July 7, 1893, *from* A Red Record *by Ida B. Wells, 1895. Because of the difficulties she was having with American audiences, Wells revised her arguments along the lines of the social-science surveys produced by the women of Hull House and by African American activist W. E. B. DuBois during these same years. Her 1895 pamphlet* A Red Record, *a scathing indictment of "white civilization," addressed "the student of American sociology" and included "Tabulated Statistics." Among the shocking data she had gathered, Wells alleged that two hours after C. J. Miller was lynched for the murder of three white girls, he was found to be innocent of the crime. Frederick Douglass praised her in his preface: "Brave woman! You have done your people and mine a service which can neither be weighed nor measured."*
SCHOMBURG CENTER FOR RESEARCH IN BLACK CULTURE, MANUSCRIPT AND RARE BOOK DIVISION, NEW YORK PUBLIC LIBRARY

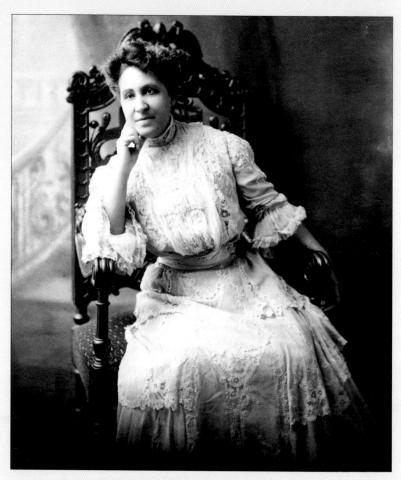

■ *Mary Church Terrell, between 1880 and 1900.* LC-USZ62-54722. CPH 3B47842

A MORE CAUTIOUS APPROACH

IN REACTION TO A MISSOURI journalist's attacks on Wells' moral character and the character of all African American women, black women's clubs nationwide banded together to form the National Association of Colored Women (NACW) in 1896. However, Wells was considered too controversial and abrasive to head a group that prized respectability and "moral motherhood." Instead, Mary Church Terrell (1863–1954), daughter of the first black millionaire in the South, graduate of Oberlin College, and wife of a future Washington, DC, municipal judge, was elected. In the association's new publication, *Woman's Era*, she declared, "We, the Colored Women of America, stand before the country today a united sisterhood, pledged to promote the welfare of our race, along all the lines that tend to its development and advancement. . . . We hope to run the whole gamut of human progress and reform. . . ." Although Terrell spoke out strongly against lynching, she made no mention of consensual sexual contact across the color line, but the NACW formed local and national antilynching committees and publicized attacks against African American women. Freed from convention in old age, Terrell led picket lines at age eighty-nine to desegregate lunch counters in the nation's capital. ■

ACTION FOR PEACE
—AND BACKLASH

THE HORRORS OF TRENCH WARFARE and a sickening death toll during the first year of the Great War in Europe rallied peace activists to call a summit meeting in The Hague. On April 16, 1915, a delegation of forty-seven American women, led by Jane Addams (behind banner, second from left), sailed from New York on the Dutch ship *Noordam*. Addams, whose peace activism dated from her opposition to the Spanish-American War in 1898, was elected the first president of what became the Women's International League for Peace and Freedom (WILPF). Attempts at a peace accord failed, but Addams maintained her pacifist position after America's entry into the war.

Before the war, Addams had been a nationally revered figure, but her steadfast pacifism turned her almost overnight into the object of vicious media attacks and hate mail. The right-wing conflation of pacifism with communism was particularly virulent in America following the Russian Revolution of 1917. Addams, appalled by the rise of racism and nativism, helped found the American Civil Liberties Union in 1920. Now demonized, she and the WILPF came under FBI surveillance, and the Daughters of the American Revolution denied her further membership. In 1931, she was awarded the Nobel Peace Prize. ■

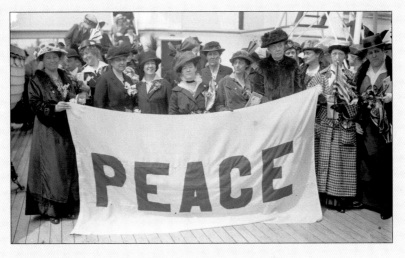

■ *Peace delegates on the* Noordam, *April 1915.* LC-B2-3443-11. GGBAIN 18848

SAINTLY REVOLUTION

DOROTHY DAY (1897–1980) shared with Jane Addams a lifelong commitment to activism for peace and social justice, but the Catholic Worker movement she created differed in important ways from Hull House. To begin with, it was both overtly religious and radical in its approach. Moreover, the charismatic Day, who had no private income and no rich friends to call on for support, was a stranger to compromise, engaging with other Catholic Worker members in nonviolent social revolution, of which voluntary poverty was a cornerstone.

Struggling to support herself and her daughter with freelance writing, Day was introduced to immigrant Peter Maurin, an itinerant French philosopher and worker. He envisioned a Catholic lay movement, which they cofounded, based on voluntary poverty and a utopian philosophy of labor involving shared surpluses on simple farms. She focused initially on his idea of a newspaper for the unemployed, to which he contributed. The first issue (May 1933) of the *Catholic Worker*, a monthly penny tabloid written and distributed by volunteers, called for a revolutionary response to the Depression based on the Gospel and the practice of works of mercy. Day soon became the voice of a new movement.

Within ten years, thirty Catholic Worker houses were established in American cities, with farming communes across the nation. However, some longtime workers left, some houses closed, and the *Catholic Worker*'s circulation plummeted due to the movement's opposition to America's involvement in World War II. Day condemned the annihilation of Japanese civilians at

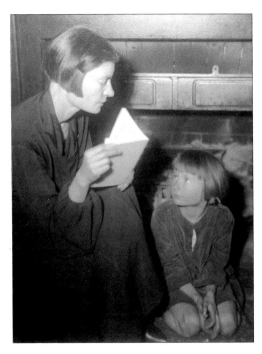

■ *Dorothy Day and her daughter, Tamar, c. 1932. After a floundering youth in radical and bohemian circles in New York City, which she described in* The Long Loneliness *(1952), Day was determined to find a compass for her daughter's life that had been lacking in her own. In 1926, she had her beloved baby baptized Tamar Teresa in the Catholic Church, which she saw as the church of immigrants and the poor, and she was baptized herself the following year. Her anarchist common-law husband, philosophically opposed to organized religion, adamantly resisted her conversion, and the relationship ended. Raised in Catholic Worker houses, Tamar married at age eighteen and had nine children.*

COURTESY OF MARQUETTE UNIVERSITY ARCHIVES

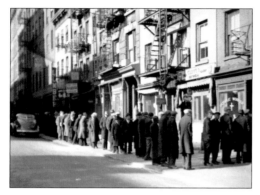

■ *Daily breadline outside Catholic Worker headquarters on Mott Street, New York, 1930s. Like so many other women reformers, Dorothy Day launched her career by seizing an opportunity offered by a social calamity, in this case the Great Depression. As increasing numbers of the poor and hungry came to seek the hospitality described in the* Catholic Worker *newspaper, volunteers arrived to share the life of voluntary poverty; thus began the Catholic Worker houses of hospitality, the most important lay movement in the American Catholic Church. Guests, many of whom were emotionally disturbed and alcoholic, ate the same food as volunteers, slept in the same dormitory, and wore the same donated clothing. As one lifelong Catholic Worker put it, "For a long time, the test of a true Catholic Worker . . . was if one could put up with bed bugs."*

COURTESY OF MARQUETTE UNIVERSITY ARCHIVES

Hiroshima and Nagasaki, and the Catholic Worker movement became a leading antinuclear voice in the 1950s.

Day's activism for peace, racial justice, and labor rights led to several imprisonments and decades of surveillance by the FBI. As opposition rose to the Vietnam War, many young people protesting the draft were drawn to Catholic Worker houses and farms in the 1960s. Day twice visited Rome on women's peace pilgrimages, fasting for ten days in 1965 while the Second Vatican Council debated questions of war and peace. Her passionate convictions profoundly influenced Catholic pacifism. More than 185 Catholic Worker communities operate today.

WORKERS FOR REFORM
AND REFORM FOR WORKERS

THE FOCUS ON LABOR by various reform movements stemmed from the severe labor unrest in America throughout the 1890s. New, struggling trade unions barred women from their ranks. Yet the 1880 census listed over two and a half million women as employed (15 percent of the workforce). By 1890, that number had swelled to over four million, including three hundred thousand girls under fifteen. This was an exploited workforce crying out for reform.

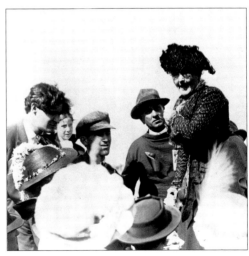

■ *Mary Harris Jones speaking in Seattle. Irish-born "Mother" Jones (1830?–1930) was a pioneer woman organizer who had moved from Tennessee to Chicago following the deaths of her husband and four children in 1867 during a yellow fever epidemic. The successful dressmaking business she established there was destroyed in the Great Chicago Fire of 1871. Destitute, she allied herself with working people who had no protection against unscrupulous employers. A fearless and electrifying speaker, scorning jail, deportation to other states, and threats on her life, Jones gained national notoriety for her efforts to organize miners in West Virginia and Colorado, and the enmity of wealthy business owners.* UNIVERSITY OF WASHINGTON LIBRARIES, SPECIAL COLLECTIONS DIVISION, UW9948

TRADE UNION REFORM

THE WOMEN'S TRADE UNION LEAGUE (WTUL)—an effort by middle-class women (known as "allies") to aid trade-union women—was cofounded in Boston in 1903 by labor organizer Mary Kenney O'Sullivan (1864–1943) and the wealthy factory inspector William E. Walling (1877–1936), with the assistance of settlement leaders Jane Addams, Mary McDowell, and Lillian Wald. The league sought to counter exploitation by organizing low-paid working women, often in the garment trades, into unions; securing the passage of protective legislation regulating their hours and working conditions; and setting minimum wage standards. Within a year, local branches of the WTUL had been established in Boston, Chicago, and New York. By 1907, Margaret Dreier Robins (1868–1945), labor supporter and daughter of a prosperous German immigrant, had emerged as the WTUL's national leader. From 1907 to 1922, she guided it through its most effective period of union organizing. WTUL members walked picket lines, worked on strike strategies, and sought funding and favorable publicity, helping to win community support. After 1922, working women took over the leadership. ■

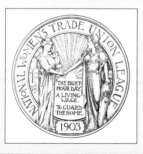

■ *OPPOSITE, AT BOTTOM: Float of Women's Trade Union League in Labor Day parade, New York, September 7, 1908.*
LC-B2-463-6. GGBAIN-02144

■ *National Women's Trade Union League seal, drawing, c. 1908.* LC-MS-34363-1 C-MSS DIV. PPMSCA-02954

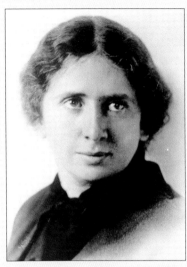

■ *Rose Schneiderman (1882–1972),*
president of the national WTUL from 1926
until its dissolution in 1950, was born in
Russian Poland to Orthodox Jewish parents
who emigrated to New York's Lower East
Side. She began work at thirteen and
launched her union career when she orga-
nized her shop into the first female local of
the Jewish and socialist United Cloth Hat
and Cap Makers' Union. In 1910 she
became the New York WTUL's full-time
organizer. Her long friendship with Franklin
and Eleanor Roosevelt began when Eleanor
joined the WTUL in 1922. Schneiderman
became a frequent guest at the Roosevelts'
homes and helped shape their views on labor
relations. LC-USZ62-112772. CPH 3C12772

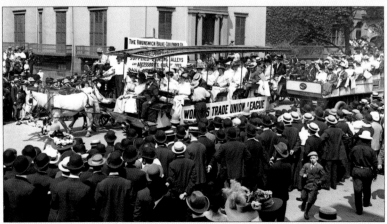

THE TRIANGLE
SHIRTWAIST TRAGEDY

ROSE SCHNEIDERMAN was one of many horrified witnesses to the Triangle Shirtwaist factory fire on March 25, 1911, in which 146 shirtwaist makers died, many after jumping from windows. An investigation showed that when the fire broke out, the mostly young immigrant women workers were trapped on the top floor by doors that had been locked or barred to prevent theft or access by union organizers. No fire drills had ever been held. Many WTUL activists had picketed the factory during the 1909–1910 strike of New York shirtwaist makers and raised more than twenty thousand dollars for the strike fund. To them and other progressives, the Triangle fire became an emotionally charged symbol. The WTUL helped organize a massive protest march down Fifth Avenue, demanded a city and state investigation of the fire, and worked to provide care for victims' survivors. An outraged Schneiderman gave an impassioned speech at a memorial meeting at the Metropolitan Opera House before thousands of spellbound New Yorkers: "I would be a traitor to those poor burned bodies," the tiny, red-haired firebrand told the audience, "if I were to come here to talk good fellowship. . . . This is not the first time girls have been burned alive in this city. . . . There are so many of us for one job, it matters little if 140-odd are burned to death." ∎

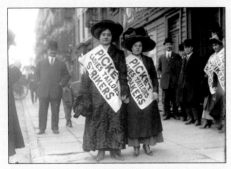

■ *Women strike pickets from Ladies Tailors, New York, February, 1910.*

LC-B2-957-1. GGBAIN-04507

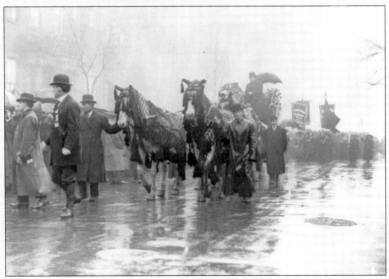

■ *Trade parade in memory of victims of the Triangle Shirtwaist Company fire, April 5, 1911.* LC-USZ62-29333. CPH 3A30009

NEW DEAL REFORM

FRANCES PERKINS (1880–1965) arguably had more influence on the labor policies of the 1930s than any other reformer. Her rise to become the first female cabinet member in the nation's history was preceded by three decades of commitment to social reform, inspired by her professors at Mount Holyoke College and her friend Florence Kelley. Needing to support her daughter and her husband, who had suffered a mental breakdown in 1918, Perkins accepted increasingly responsible industrial regulatory appointments in the Democratic administration of New York governor Alfred E. Smith. She was the state's industrial commissioner when Franklin Delano Roosevelt became governor, and he reappointed her to this position. Perkins worked for protective legislation for women, convinced "that the best way to improve conditions for workers was through legislation, not unions."

Leading women reformers, including Eleanor Roosevelt, pushed for Perkins' nomination as FDR's secretary of labor. Steadfast and extremely hard working, she became one of only two cabinet members to serve throughout FDR's presidency (1933–1945), helping him to draft legislation, including such landmark reforms as the Wagner Act, which gave workers the right to organize unions and bargain collectively; and the Fair Labor Standards Act, which established for the first time a minimum wage and maximum workweek for men and women, and ended child labor in factories. She also rebuilt the Department of Labor and chaired the committee that helped develop the Social Security Act of 1935.

When Perkins died in May 1965, Secretary of Labor W. Willard Wirtz paid tribute to her: "Every man and woman who works at a living wage, under safe conditions, for reasonable hours, or who is protected by unemployment insurance or Social Security, is her debtor." ■

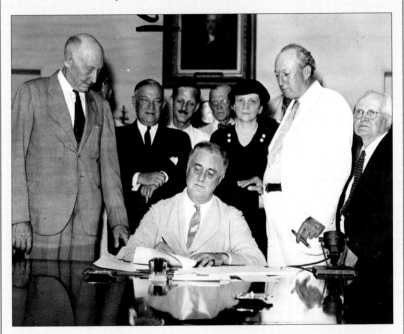

■ *Frances Perkins and US congressmen witness the signing of the Social Security bill by President Franklin D. Roosevelt, 1935.* LC-USZ62-123278. CPH 3C23278

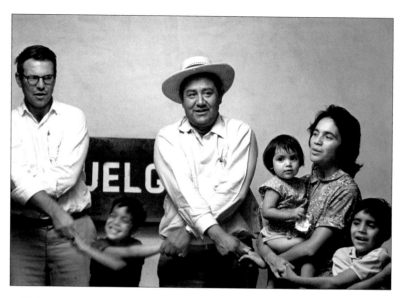

■ *Dolores Huerta and three of her children join in singing "De Colores" at the end of an organizing meeting, 1966. An important innovator of grassroots organizing, Huerta (b. 1930) cofounded with César Chávez the National Farm Workers Association, which later became the United Farm Workers of America (UFW). The New Deal had explicitly excluded agricultural laborers in its safeguards for American workers. Farm labor was tangled up in immigration issues and racist attitudes toward Mexican Americans. Huerta and Chávez modeled their crusade on the civil rights movement, and the UFW also took advantage of the growing concern about pesticides. By 1965, they had recruited farmworkers and their families throughout California's San Joaquin Valley and voted to join another agricultural union in a strike against area grape growers. The bitter strike lasted five years but resulted in the entire California table-grape industry signing a three-year collective bargaining agreement with the UFW.*

PHOTOGRAPH © 1978 GEORGE BALLIS/TAKE STOCK

HAVING IT ALL!

MARGARET SANGER (1879–1966), despite enormous resistance, popularized the idea that women's liberation—and, indeed, human progress—depends on access to a safe and reliable means of preventing pregnancy.

Sanger worked part-time as a visiting nurse and midwife in the immigrant districts of New York City's Lower East Side. Awakened to the need for "fundamental social change" by the death of a patient after a self-induced abortion, she began publishing, in 1914, *The Woman Rebel*, a radical feminist journal that advocated sexual autonomy for women through birth control. In the 1870s, the federal government and almost every state had adopted obscenity statutes, the Comstock Laws, that criminalized contraception and abortion and prohibited the sale or distribution of related information or products. Although her paper never explicitly published contraceptive information, Sanger was indicted under these laws for promoting obscenity and inciting violence. Facing a likely prison sentence, she jumped bail, fled to Europe, and then ordered the release of her pamphlet *Family Limitation*, which provided birth-control instruction. Her husband chose a jail term rather than pay a $150 fine for distributing the pamphlet. Encouraged by news of broad public support, Margaret Sanger decided to return to America and face trial. Instead, all charges were dropped against her, and she had become a celebrity.

Sanger remarried in 1921, and her businessman husband funded the prototype for a network of birth-control facilities around the country. She also published two best-selling books on the implications of birth control. The movement stalled during the Great Depression and World War II because the votes of conservative Catholics in big cities and fundamentalist Protestants in

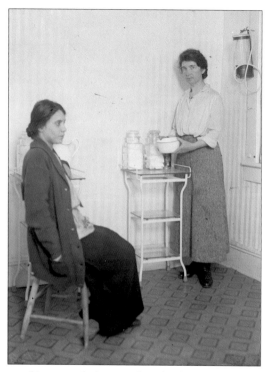

■ *The tragic death of her daughter from pneumonia inspired Margaret Sanger (shown standing) to memorialize her by opening the country's first birth-control clinic in 1916 in Brooklyn. The clinic had 464 recorded clients during the several weeks that it remained open, but on its ninth day of operation three officers from the police department's vice squad arrested Sanger, her sister, and others working in the clinic. Found guilty of fitting a birth-control device, she served a month's sentence in the women's penitentiary in Queens County. She wrote later, "The poor, especially the immigrant poor, could not understand the many popular subterfuges through which it [birth control] was sold, such as feminine hygiene." Among her papers are many advertisements for such devices, including one for the "Dainty Maid" douche bag, antiseptic powder, and syringe (see opposite).*

LC-B2-4050-2. GGBAIN 23218

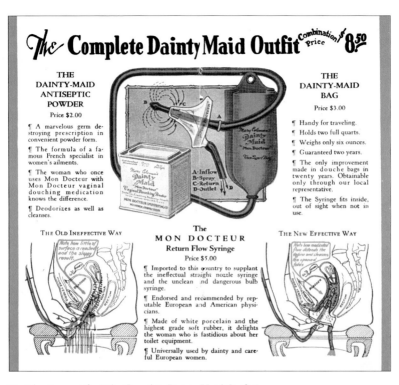

The Complete Dainty Maid Outfit

Combination Price **8.50**

THE DAINTY-MAID ANTISEPTIC POWDER

Price $2.00

¶ A marvelous germ destroying prescription in convenient powder form.

¶ The formula of a famous French specialist in women's ailments.

¶ The woman who once uses Mon Docteur with Mon Docteur vaginal douching medication knows the difference.

¶ Deodorizes as well as cleanses.

THE DAINTY-MAID BAG

Price $3.00

¶ Handy for traveling.

¶ Holds two full quarts.

¶ Weighs only six ounces.

¶ Guaranteed two years.

¶ The only improvement made in douche bags in twenty years. Obtainable only through our local representative.

¶ The Syringe fits inside, out of sight when not in use.

A-Inflow
B-Spray
C-Return
D-Outlet

THE OLD INEFFECTIVE WAY

The MON DOCTEUR Return Flow Syringe

Price $5.00

¶ Imported to this country to supplant the ineffectual straight nozzle syringe and the unclean and dangerous bulb syringe.

¶ Endorsed and recommended by reputable European and American physicians.

¶ Made of white porcelain and the highest grade soft rubber, it delights the woman who is fastidious about her toilet equipment.

¶ Universally used by dainty and careful European women.

THE NEW EFFECTIVE WAY

■ *Advertisement for "The Complete Dainty Maid Outfit."*

LC-MS-38919-8C-MSS DIV. PPMSCA 02880

the rural South were critical to FDR's coalition of support. However, in 1948 Sanger established the London-based International Planned Parenthood Federation, which remains today the largest nongovernmental provider of contraceptive services in the world and her most enduring contribution.

WOMAN REFORMERS IN CONGRESS

MARTHA GRIFFITHS AND BELLA ABZUG exemplify Congresswomen who significantly advanced the cause of women's rights during the civil rights era of the 1960s and 1970s.

Martha Griffiths (1912–2003), a lawyer and Democratic representative from Michigan for twenty years, was instrumental in adding sexism to the types of discrimination prohibited in the landmark 1964 Civil Rights Act. She also guided the Equal Rights Amendment through the House of Representatives after collecting enough signatures on a discharge petition to force it out of the Judiciary Committee, where it had languished for two decades under the chairmanship of pro-labor New York congressman Emanuel Celler. He felt, as did many woman labor activists, that it threatened existing protective labor laws.

Bella Abzug (1920–1998) was a born reformer, boldly protesting injustices against women and minorities and organizing campaigns for women's rights, human rights, and peace. Challenging the Democratic Party machine, she was the first person elected to Congress on a women's rights/peace platform, in 1970. Famous for her wide-brimmed hats and colorful personality, she either wrote or helped pass an extraordinary amount of legislation during her six years in the House: the Equal Credit Act; Title IX regulations, enforcing equal opportunity for women in federally funded schools; and pioneering legislation for comprehensive child care, Social Security for homemakers, family planning, and abortion rights. She introduced an amendment to the Civil Rights Act to include gay and lesbian rights, organized the congressional caucus on women's issues, and cofounded the National Women's Political Caucus in 1971. ■

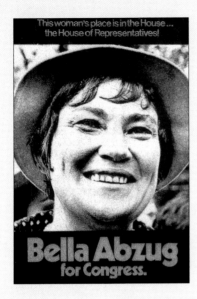

■ This Woman's Place Is in the House—
the House of Representatives! Bella
Abzug for Congress, *poster, 1970s.*
LC-USZ62-109588. YAN 1A38519

■ *Representative Martha Griffiths*
(D-Michigan) in front of
the US Capitol,
August 12, 1970.
LC-U9-23069-20. PPMSCA 02968

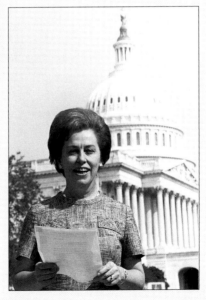

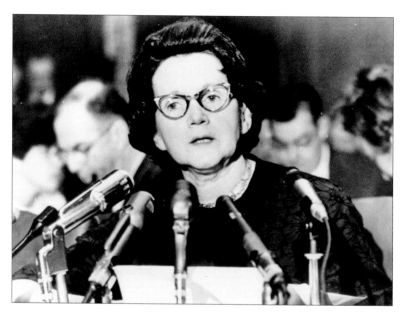

■ *Rachel Carson speaking before a Senate Government Operations subcommittee study-*
ing pesticide spraying, June 5, 1963. President Kennedy had asked for a closer scientific
look at the questions raised by Silent Spring. *His Science Advisory Committee's report,*
made public on May 15, 1963, strongly supported the scientific correctness and impor-
tance of Carson's findings. On June 5, despite the fact that she was losing her battle with
breast cancer, Carson appeared before a Senate subcommittee studying "Activities Relat-
ing to the Use of Pesticides." Senator Ernest Gruening of Alaska was among those who
praised her: "Miss Carson, every once in a while in the history of mankind a book has
appeared which has substantially altered the course of history. . . . Your book is of that
important character, and I feel you have rendered a tremendous service."

LC-USZ62-111207. CPH 3C11207

INTELLECTUAL TORCHBEARERS FOR MODERN REFORM

THREE WOMEN—Rachel Carson, Jane Jacobs, and Betty Friedan—launched major reform movements with the publication of seminal books in the early 1960s. Carson's *Silent Spring* inspired the environmental movement; Jacobs' *Death and Life of Great American Cities* influenced "new urbanism"; and Friedan's *Feminine Mystique* sparked the second wave of the women's rights movement.

Rachel Carson (1907–1964) retired early from the United States Fish and Wildlife Service, where she had been a scientific editor, to write more books about nature. Disturbed by reports of fish and wildlife kills following aerial spraying of chemical pesticides, she switched her focus to a broad investigation and analysis of relevant scientific research. *Silent Spring,* four and a half years in the making, was published in September 1962. "Along with the possibility of the extinction of mankind by nuclear war, the central problem of our age has become the contamination of man's total environment with substances of incredible potential for harm," she wrote.

Such passionate assertions led to a nationally publicized struggle between proponents and opponents of pesticides, showcased on the CBS program *The Silent Spring of Rachel Carson,* which aired on April 3, 1963. The program included a dramatic on-screen showdown between Carson and a research executive for the American Cyanamid Company. Responding frostily to his allegation that her claims were gross distortions and that man's very survival would be threatened by voracious insects if chemical pesticides were banned, she retorted, "It is not my contention that chemical pesticides must never be used. . . . We must know the consequences."

The Death and Life of Great American Cities (1961) by Jane Jacobs (1916–2006) was to urban planning what Carson's *Silent Spring* was to the environmental movement. While raising a family in New York City's lively Greenwich Village neighborhood, Jacobs wrote for *Architectural Forum* magazine as an "expert" on city planning, even though she lacked a college degree. She severely criticized the 1950s urban-renewal movement, which was displacing thousands of residents from their neighborhoods and communities into cheaply built, soul-destroying housing projects in which they were isolated from shops and daily human interaction. "There is a quality even meaner than outright ugliness or disorder and this meaner quality is the dishonest mask of pretended order, achieved by ignoring or suppressing the real order that is struggling to exist and to be served." Instead she prescribed more diversity, density, and dynamism of buildings and people, where people are safer from crime because they are hardly ever alone. Jacobs' book rocked the planning and architectural establishment, some of whose members lashed back, accusing her of rank amateurism and aesthetic philistinism.

A feisty street activist, Jacobs was forcibly ejected from a City Planning Commission hearing on an urban renewal program for Greenwich Village after she and others leaped from their seats and stormed the podium. In 1968 she was arrested for disrupting a public meeting on the plans proposed by the autocratic master developer Robert Moses for putting a new expressway through Manhattan's Soho district. The expressway's opponents won. Noted one former adversary of the outwardly folksy intellectual pioneer, "What a dear, sweet character she isn't."

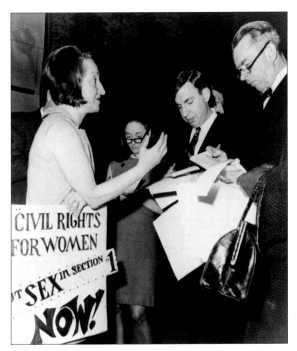

■ *Betty Friedan, president of the National Organization for Women, tells reporters in the New York State Assembly lobby of the group's intention to "put sex into section I of the New York constitution," April 4, 1967. The federal government's reluctance to enforce the sex-discrimination amendment to the 1964 Civil Rights Act, as well as the climate of demeaning male attitudes toward women—many of whom were educated in elite universities—in the New Left student and civil rights movements of the 1960s, led Friedan and others to found the National Organization for Women (NOW) in 1966. Friedan, who became the organization's first president, drafted NOW's statement of purpose: "to take the actions needed to bring women into the mainstream of American society, now, full equality for women, in fully equal partnership with men."* LC-USZ62-122632. CPH 3C22632

Betty Friedan (1921–2006) pointed the way to the modern women's movement with the publication of *The Feminine Mystique* in 1963. "The problem that has no name" was her term for the discontent felt by millions of white, middle-class, heterosexual, educated American women, starting with herself, who wanted roles beyond those prescribed by a newly conservative American society following World War II. She castigated advertisers for encouraging women to be consumer-housewives. As later critics have pointed out, the book ignored the problems of millions of poor or nonwhite working women, but its huge success launched Friedan's career as a lecturer and activist and brought fresh blood and renewed passion to the women's movement.

Friedan's relationship with other leaders of NOW became troubled by the divisive issue of sexual preference and by anti-male, anti-family rhetoric. Although divorced, she had never turned against men and was traditional in her love of family. She resigned as president and turned her energies to cofounding the National Women's Political Caucus (NWPC) in 1971 with New York Democratic congresswomen Bella Abzug and Shirley Chisholm, and *Ms.* magazine founder Gloria Steinem. The NWPC won a lasting victory when it convinced the Democratic National Committee to guarantee equal representation for women at Democratic conventions. In addition, the two organizations she cofounded successfully lobbied Congress to obtain minimum wage for domestic workers, educational equity, equal access to credit, female admission to military academies, and job protection for pregnant workers, while lawyers working for the women's movement brought *Roe v. Wade* to the Supreme Court.

The stories of these daring women indicate certain periods of intense reform activity: the 1830s and 1840s, the late nineteenth and early twentieth centuries, the 1930s, and the 1960s. In each case, a war redirected reformist energy. Today economic realities—the need for two incomes to raise a family—have ensured women's continued participation in the public sphere while depriving most of them of the time for volunteerism. Indeed, with the modern tendency to rely on government agencies to safeguard social welfare, cultural critics fear that the moral imperative is vanishing from contemporary society. Perhaps a new generation will disprove this pessimistic assessment. Many idealistic young people are already lending their energy and education to a wide variety of causes. ■

RELATED RESOURCES AND
SELECTED BIBLIOGRAPHY

The Library of Congress has numerous materials that document American women's involvement in reform movements, in addition to its voluminous suffrage collections. Of particular note are the papers of the National Consumers' League, National Women's Trade Union League of America, National Association for the Advancement of Colored People, and the Margaret H. Sanger Papers. These and other materials are described in *American Women: A Library of Congress Guide for the Study of Women's History and Culture in the United States* (Washington, DC: Library of Congress, 2001). To access this guide online, along with related Library of Congress resources, visit http://memory.loc.gov/ammem/ and follow the "Women's History" link.

The following is a limited selection of the many sources that were consulted in compiling this book:

Beecher, Catherine E. *A Treatise on Domestic Economy, for the Use of Young Ladies at Home, and at School*. New York: Harper & Brothers, 1845.

Berson, Robin K. *Jane Addams: A Biography*. Westport, CT: Greenwood Press, 2004.

Brooks, Paul. *The House of Life: Rachel Carson at Work*. Boston: Houghton Mifflin, 1972.

Chesler, Ellen. *Woman of Valor: Margaret Sanger and the Birth Control Movement in America*. New York: Simon & Schuster, 1992.

Cimbala, Paul A., and Randall M. Miller, eds. *Against the Tide: Women Reformers in American Society*. Westport, CT: Praeger, 1997.

Herrmann, Frederick M. *Dorothea L. Dix and the Politics of Institutional Reform*. Trenton, NJ: New Jersey Historical Commission, 1981.

James, Edward T., ed. *Papers of the Women's Trade Union League and Its Principal Leaders: Guide to the Microfilm Edition*. Woodbridge, CT: Research Publications, 1981.

Kent, Deborah. *Dorothy Day: Friend to the Forgotten*. Grand Rapids, MI: William B. Eerdmans, 1996.

Notable American Women. Five unnumbered volumes. Cambridge, MA: Belknap Press, 1971 (vols. 1–3), 1980, 2005.

Schechter, Patricia A. *Ida B. Wells-Barnett and American Reform, 1880–1930*. Chapel Hill, NC: University of North Carolina Press, 2001.

Schiff, Karenna Gore. *Lighting the Way: Nine Women Who Changed Modern America*. New York: Miramax, 2005.

Schneiderman, Rose, with Lucy Goldthwaite. *All for One*. New York: Paul S. Eriksson, 1967.

Sklar, Kathryn Kish. *Catharine Beecher: A Study in American Domesticity*. New Haven, CT: Yale University Press, 1973.

Sterling, Philip. *Sea and Earth: The Life of Rachel Carson*. New York: Thomas Y. Crowell, 1970.

Wells-Barnett, Ida B. *Southern Horrors and Other Writings: The Anti-lynching Campaign of Ida B. Wells, 1892–1900*. Edited by Jacqueline Jones Royster. Boston: Bedford Books, 1997.

Willard, Frances E. *How I Learned to Ride the Bicycle: Reflections of an Influential 19th Century Woman*. 1895. Edited by Carol O'Hare. Sunnyvale, CA: Fair Oaks, 1991.

ACKNOWLEDGMENTS

The author would like to thank Amy Pastan, for helping her find a way to tell such a large and complicated story in a very small book, and the Library of Congress' Publishing Office, for giving her the opportunity to return to her favorite subject, daring and imaginative women and the societal challenges they confronted. She would also like to thank Janice Ruth, women's history specialist in the Library's Manuscript Division, for her comments on the initial selection of reforming women.

IMAGES

Reproduction numbers, when available, are given for all items in the collections of the Library of Congress. Unless otherwise noted, Library of Congress images are from the Prints and Photographs Division. To order reproductions, note the LC or digital ID number provided with the image; where no number exists, note the Library division and the title of the item. Direct your request to:

The Library of Congress
Photoduplication Service
Washington DC 20540-4570
(202) 707-5640; www.loc.gov